T0102035

Judy Chicago-isms

Judy Chicago-isms

Judy Chicago

Edited by Larry Warsh

PRINCETON UNIVERSITY PRESS

Princeton and Oxford

in association with
No More Rulers

Published by Princeton University Press,
41 William Street, Princeton, New Jersey 08540
In the United Kingdom: Princeton University Press,
99 Banbury Road, Oxford OX2 6JX
press.princeton.edu
in association with
No More Rulers
nomorerulers.com
ISMs is a trademark of No More Rulers, Inc.

All Rights Reserved

ISBN 9780691253961
Library of Congress Control Number 2023009988
British Library Cataloging-in-Publication Data is available

This book has been composed in Joanna MT
Printed on acid-free paper. ∞
Printed in China
1 3 5 7 9 10 8 6 4 2

CONTENTS

INTRODUCTION

Over a long and productive lifetime, Judy Chicago has said many memorable things. But the line that reverberates most strongly for me is the one printed on the back cover of this book: "What if women ruled the world?" That question is typical Judy Chicago. It's clear, incisive, and makes us stop and think. It goes straight to the heart of her creative and cultural endeavors, which she would probably say are one and the same.

Born Judith Sylvia Cohen in Chicago in 1939, by the age of five Chicago knew she wanted to be an artist. Growing up, she attended classes at the Art Institute of Chicago. At UCLA she earned a BFA in 1962 and an MFA in 1964. By the late 1960s she was one of the few women artists to gain traction in the male-dominated LA art scene.

Despite pressure to be "one of the boys," Chicago's art of that time determinedly explored her own sexuality. Moving into performance and land art, she began experimenting with colored smoke, dry ice, and firework performances. Called "Atmospheres," these works were intended to soften or "feminize the landscape," as she put it. In 1970 she renounced her married and birth surnames, claiming her hometown as her identity—and in the process calling into question the patriarchal implications underlying so much of our culture.

The early 1970s saw a groundswell of feminist art and writing. Chicago was a leading figure in the emerging movement, as an educator as well as an artist. She cofounded the Feminist Art Program at California State University, Fresno—the first such program in the nation—and set about developing a feminist approach to art

education. Bringing a similar program to the California Institute of the Arts, Chicago and Shapiro organized the installation and performance space *Womanhouse* (1971–72). A critical exploration of female roles within a domestic framework, *Womanhouse* involved twenty-one artists. Installations included eggs on a kitchen ceiling morphing into breasts as they descended the walls, and Chicago's own contribution, a bathroom focused on menstruation.

In 1974 Chicago began her most renowned work, *The Dinner Party* (1974–79), a massive installation now on permanent view at the Brooklyn Museum. Conceived as a ceremonial banquet, it includes a triangular table—measuring forty-eight feet per side—that holds thirty-nine place settings, each commemorating an important mythical or historical female figure. The place settings include embroidered runners, gold chalices

and utensils, and porcelain plates with raised central motifs based on Chicago's signature vulvar and butterfly motifs. On the white tile floor, the names of 999 more women are inscribed in gold. Hundreds of women collaborated on the project, contributing ceramics, needlework, fabrication, photography, and more.

Building on the success of *The Dinner Party*, Chicago turned to other ways in which women and their experiences—notably childbirth—had been shut out of art and art history. The Birth Project (1980–85) is a series of birth and creation images that were executed under her supervision by 150 needleworkers around the country. During that time she also completed *PowerPlay*, a series of large-scale drawings, paintings, and other works that turned a critical feminist eye toward the construct of masculinity.

Those explorations of power and powerlessness led her to a sustained engagement with issues of her own Jewish identity, which came to light in the *Holocaust Project: From Darkness into Light* (1985–93), done in collaboration with her husband, photographer Donald Woodman. In *The End: A Meditation on Death and Extinction* (2012–18), Chicago continued to meld the personal and the political as she faced her own mortality and confronted one of our culture's deepest taboos. In 2020, she designed the space for the Christian Dior Spring-Summer Haute Couture Show in Paris, which was part of a forty-five-foot-high inflatable sculpture, *The Female Divine*, that she had envisioned in the 1970s. There, models catwalked under banners that responded, with more questions, to that one unforgettable question: "What if women ruled the world?"

And at eighty-three, Judy Chicago is not done yet. During Miami Art Week this past December, she made that provocative question the basis of another collaboration—this time, with Nadya Tolokonnikova, a founder of the Russian collective Pussy Riot. Inspired by the banners from the 2020 Dior show, the participatory project will use blockchain to enable the public to respond to the questions that those banners posed. "We want men and women all over the world to think about how we can reclaim our humanity, reclaim how we talk to each other, and most importantly enough, to reclaim the planet," Chicago said at the launch event.

I began this introduction by noting that over the course of her lifetime, Judy Chicago has said many memorable things. It's profoundly satisfying to me that so many of them appear between the covers of this book—her thoughts on art and

creativity, on living life, on feminism, and on the future of humanity and the planet we inhabit together. Few artists speak as frankly and directly as Judy Chicago, and we are all the better for it.

LARRY WARSH
NEW YORK CITY
JANUARY 2023

Judy Chicago-isms

Art and Creativity

What do human beings do? We make signs, we make symbols, we make marks, we make gestures—it's something that crosses gender, ethnicity, individual identities. (12)

———

If you think about what makes us human, it is our hands—the gestures we make, the words we make, the music we write, the art we make. (23)

———

I always believed in the power of art. (75)

———

Making art is and has been a journey of discovery. I become interested in an idea and pursue that idea wherever it takes me. (76)

———

Discovery. I think that's the biggest, most important word in my life. (30)

———

Art does not have to be huge in order to be important or moving. (91)

———

Art should be beautiful, but the function of beauty and art is to convey ideas. (26)

———

The best art for me has always been both beautiful and terrible at the same time. (17)

———

If we can't deal with anybody's experience ut our own, that just about wipes out the history of art, doesn't it? (53)

———

The quickest way to not be original is to not know what other people have done, because that will guarantee that you will do something that has already been done a hundred times before. (34)

———

Women's art must be seen in the larger context of both women's history and women's struggle for self-expression. Without that framework, each woman's achievement threatens to be seen as an exception, rather than another link in the long chain of accomplishments that will one day be recognized. (58)

———

I needed to find a way to embody the human condition in terms of female experience, and that required that I study women's art. I wanted to find out if other women had left clues in their work that could help me. I wanted to explore my experience as a woman openly and somehow wed those to the sophisticated techniques and skills I had as an artist. (37)

———

It's no accident that in the three arts—literature, art, and music—literature was the first avenue in which women were able to excel because … it only takes a pencil and one other person, an editor who believes in you, to bring what you write into public view. (29)

Images by men, of women are "art"; images by women, of men are "political." Abstract patterns by men are "art"; abstract patterns by women in fabric are "decorative"; they're called quilts. So there's all these kind of double standards and all these kind of words that prevent women's experience from entering— even when they express it—from entering the mainstream of art. (48)

———

Art isn't gendered, but artists are. (26)

———

In the sixties, the highest compliment a woman artist could get is "you paint like a man." (14)

———

My gender so interfered with culture's ability to see my work, that it was met with … resistance and shock. (60)

————

Even though I feel grateful for the amount of attention *The Dinner Party* brought me, it also blocked out the rest of my work. (28)

————

I am often asked how I survived the often-vitriolic criticism of my work; my answer is always the same. I learned my history as a woman. I studied the work of my predecessors and came to understand the obstacles they had to overcome in order to achieve their goals.

(55)

————

Time is freedom. (7)

———

Anger can fuel creativity. (3)

———

It's not comfortable to look at my work,
but I don't think art's function is to make you
comfortable. I think art's function is to
make you think. (43)

———

There's been a lot of art by women that might
be woman centered, but isn't very accessible.
For me that's not feminist art. (52)

———

Feminist art and women's art are two different things. (30)

———

I don't think only women can make feminist art, because it's just a way of seeing the world with a gender lens. (40)

———

I'm interested in getting the male viewer to identify with my work, to open his eyes to a larger human experience. (36)

———

I've had to spend an awful lot of time educating viewers and the art world about the right women artists have to use our own experiences as subject matter for art. (14)

———

If one wants to succeed as an artist, one has to be prepared for a long, sustained push ... the faster you go up, the quicker you go down.

(89)

———

Before I get interested in somebody, they have to have a long, sustained career. Because that's what real art grows out of. (11)

———

Some people say that their life is their art. For me, making art is a very specific act that involves creating a symbolic reality. The idea that other things are art, I just don't accept any of that. (44)

———

I feel very alienated from most art that's made; it exists in narrow strata and does not come out of the depths of human emotion and experience. (36)

———

I was raised to think that artists should work in isolation. But if you look at the history of art, artists have worked that way only since the Industrial Revolution. Previously, there were guilds and then ateliers. And there were also convents and monasteries where women worked together as embroiderers and scribes. (17)

———

How would I have ever in New York imagined
that I could create a feminist art practice or
a feminist art education? That came out
of the spirit of [Los Angeles]. (73)

———

As art becomes about ever bigger production
studios with more and more people
producing objects that the artists never touch
with their own hands, to fill up these huge
galleries, I'm all by myself, in my studio,
with my paintbrush, working small. (40)

———

I don't want the people I work with to be like robots. I want them to bring their best to the collaboration, I want to create projects or images that allow my collaborators to bring their skills and their ideas to it because I believe that's the way to get the best result. (62)

———

Art, like women's power and health, has been co-opted for the benefit of the few. (33)

———

I have a very different vision of art. I'm very against the "plop the piece down and screw you" attitude. (10)

———

I wish I could make collectors understand that the worth of art is in the nature of the work and not in its market value. (71)

———

[Art has] gotten confused with commerce as opposed to being understood as the deepest expression of the human spirit. (74)

———

One should always trust one's own impulses as an artist, even in the face of rejection, ridicule, or silence. (24)

———

When I was getting nothing in terms of reward or recognition, I made my studio work my reward. (30)

———

My career demonstrates that one never knows
what can happen if you forge your own
vision, persist in its evolution and stay true to
it, which is increasingly difficult in today's
money-driven art world. (70)

———

There is a big audience for art of meanings, of
art that addresses the issues that most people
care about, and that art is hard to find. (4)

———

I want to make some new bridge between
artists and community. I want to demystify
the process of making art. (36)

———

I have made a concerted effort over the years
to avoid political "messages"; that is not what
I am about. My work deals with moral issues.
(70)

———

The visual objects I have spent my life making
are the things I want people to have access to,
not just my words or my ideas, but my art.
(44)

———

I am critically aware of art's limits. (79)

———

I do not think art can change the world.
I think that art can educate, inspire, empower
people to act. (9)

———

I want viewers to understand why the subject
matter is important; if that creates empathy,
I'm glad. And if it leads to change, I'd
be even happier. (94)

———

I always believed in the power of art. But *The
Dinner Party* taught me that the power of art
was way beyond anything I had ever
actually imagined. (92)

———

Art is the symbol face of reality. A new
paradigm in art can represent the beginning
of a new era on the Earth. (79)

———

Art matters if artists use their talents to
help us find our way. (80)

———

We need to wake up. Artists can sound
the alarm. (80)

———

Art has no responsibilities. Only artists
have responsibilities. (69)

———

Even if there's a long way to go, art can still
strike a blow for freedom—for everyone. (81)

———

Make trouble and kick ass! (90)

———

Form and Content

Art without content is like sex without intimacy: technically sufficient, but emotionally empty. (48)

———

I don't believe that one has to make gigantic work in order to deal with important subject matter. (21)

———

[Georgia] O'Keeffe was our real pioneer, the first woman to stand her ground and make a form language that could deal with the whole range of human experience. (36)

———

I'm a content-driven artist. Different content is best expressed in different forms. (46)

———

I never liked oil paint, I never liked
imposing paint on the surface. (51)

———

Approaching my body, the body of the
earth, the body of a canvas: for me it's all the
same. It's approaching it with awe and wonder
and reverence, rather than the impulse
to dominate. (94)

———

I think through drawing. It's very basic
to my practice. (77)

———

My thinking follows my art. I don't always
know what's motivating me to take up a
subject. I discover it, usually, in the
process of working. (52)

———

It is popular to say that I elevated women's craft into high art. But, not only had I apprenticed myself to china painters and learned about the history of needlework the decade before—I had gone to autobody school, and had apprenticed myself to boat builders when I wanted to do fiberglass. It is just that those different techniques have been gendered by the historic framework of art. And I just do not think like that. (86)

———

The idea that techniques are gendered seemed ridiculous to me. I approached plastics or spray painting the same way I approached needlework or china painting. (31)

———

When you change materials, the
meaning changes (25)

———

I like to start over; I like to have nothing
around me to remind me of anything
I'd done before. (30)

———

New content requires new forms. (62)

———

Whatever medium I am working in at the
moment becomes my favourite. (50)

———

There's a lot of humor in my work that
people often don't notice. (23)

———

I can't relate to work that is cerebral and has
to do with process or the nature of art.
That's dehumanized. (36)

———

I was interested in subverting the painting
method of the great Renaissance paintings
because if modern society was born back
then, so, too, was our distorted concept
of the male heroic. (54)

———

Subversion is very basic to my work. (54)

———

Male representation of women is often
misogynist but because misogyny inflects
our political system, it isn't deemed political.
My work "opposes" the mainstream in its core
values. It is not about politics; it is about
another view of reality. (70)

———

Since the beginning, you could say that
I have had an interventionist practice.
I intervened in an art tradition that was
slanted entirely toward the male and male
interests; I intervened in male minimalism
with emotive color; I intervened in
domineering land art with my smoke pieces;
I intervened in the absence of information
about women's history, and I intervened
in the absence of imagery about birth. (1)

———

Male-centered imagery, which is
often construed to be universal, has so
shaped our consciousness that you could
say that *The Dinner Party* was an
intervention into that. (20)

———

Do you see your art as political?
No more than Picasso was political. (44)

———

I suppose one could say that my art became
my politics in that I decided to create art
that openly challenged the patriarchal
paradigm that prevailed. (24)

———

Feminist art is grounded in a challenge to the
prevailing value structure of our world. (13)

———

Feminist art is all the stages of a woman
giving birth to herself. (13)

———

If men could give birth, there would be
millions of representations of the crowning.
(2)

———

The feminist art movement is not one style.
It is a multiplicity of styles, and feminist art
can only be identified by its content. (46)

———

My work has always had that double-sided,
many-layered aspect; the sense of being
both in-and outside the form. (17)

———

I started with a vaginal form. I was interested
in starting to see what I could do with that
form what men had done, which is make
what's called universal forms. (14)

———

When you walk around New York City, nobody goes around and says, "Oh, look at that, it's a phallus! It's a phallus! It's a phallus! Oh, look at that phallus. It's got a pointed top." Nobody says that because we are so accustomed to the idea that that imagery is universal, even though it excludes half of the human race. (14)

———

My goal as an artist has been to create images in which the female experience is the path to the universal, as opposed to learning everything through the male gaze. (29)

———

It is a breakthrough for me to move from cunt as subject to cunt as formal device. (38)

———

When I started trying to universalize from a female form base, turning vaginal form into a cave, a flower, a butterfly, it was met with shrieks of horror. (14)

———

I wanted to validate overt female subject matter in the art community and chose to do so by making *Red Flag* as a handmade litho, which is a high art process, usually confined to much more neutralized subject matter. By using such overt content in this form, I was attempting to introduce a new level of permission for women artists. (35)

———

I see the development of abstraction as very important in the development of a female point of view in art. Before that it was simply not possible to deal with certain areas of experience and feeling. (36)

———

If one allows oneself to meet my paintings on an emotional level, one can penetrate the plastic and the formalism and find that soft center I was trying to expose. (36)

———

Control isn't what I'm interested in. Transformation is a better word. (68)

———

I cross contexts, and it is incomplete to only talk about my work in terms of feminist art.

(41)

———

You always have to stop just before it's perfect; you know if you just go one more second and try and make it perfect, you'll lose the picture.

(36)

———

Trust yourself, even if people don't understand what you're trying to do. Don't give up. (26)

———

Life and Identity

From the time I was young I wanted
to be an artist. (49)

———

I started drawing before I started talking. (7)

———

My parents believed in equal rights for
women, which did not exactly prepare
me for the real world. (12)

———

At an early age I learned that even if everybody
believes something, it doesn't make it true.
(92)

———

Throughout my childhood, my mother worked, a situation which, I suppose, gave me a sense that women "did" something in the world. (49)

———

I had a Marxist father who brought me up to think money wasn't important, so "art equals money" was not anything that was ever in my mind. (7)

———

When I was a little girl, my father, [who] was a Marxist, used to have these political meetings in our house ... and he always included the women, even though this was like the forties. (5)

———

For a young woman of my generation,
it was very unusual to be fathered, but I was.
My father used to play these games with me
intended to teach me values. (7)

———

My father taught me about equality, and
he taught me to judge people based on who
they are, not on their supposed position,
their power, whatever. (12)

———

My father really was of that generation [who]
thought they were going to change the world,
and he was training me to think that I had an
obligation to make a contribution. (7)

———

My family's aspirations for my younger brother, Ben, and me involved encouraging us to "make a difference," a notion that seems almost inconceivable in today's money-driven climate. (61)

———

I grew up looking at the impressionist paintings in the Art Institute of Chicago. I wanted to become part of the art history represented there. (66)

———

I had a burning desire to make art. That was the most important thing to me in my life. I'd give up everything for it. (3)

———

My goal was always to make a contribution
to art history. (9)

———

I'm an artist who cares passionately
about meaning in art, who has pursued paths
of interest whether they were fashionable,
popular, commercially successful or not. (65)

———

Socialization is like knitting a coat that you
wear even though it doesn't fit so well. (33)

———

Everybody can define themselves, their
own identities. (6)

———

We have to take hold of our own image. Take it
over. That's why I changed my name. (27)

———

I reject the definitions society has given
me because the definitions society has
given me are non-operable. (27)

———

I shall determine who I am. (27)

———

Judy Gerowitz hereby divests herself of
all names imposed upon her through male
social dominance and freely chooses her
own name Judy Chicago. (16)

———

I changed my name legally. I did not use an alias. I elected to use the legal process because married women are nonpersons legally and I wanted a name of my own. (38)

———

[In the 1960s], any hint of gender in one's work instantly disqualified one as a serious artist. You couldn't even be caught cooking in front of an art-world person or you'd be consigned to either the role of the girlfriend or the wife. (92)

———

I went to auto-body school, because I wanted to learn to spray-paint, and because it seemed another way to prove my "seriousness" to the male art world. (36)

———

[Auto-body school] was really transformative
for me because, you know, I was raised as a
female person. My family was a middle-class
Jewish family. They don't do mechanical stuff.
(7)

———

There was no term "feminist art" when
I started out. (44)

———

After nearly a decade of what I describe as
"male drag" (i.e., making art which disguises
the gender of the female artist), I rebelled and
sought to unite my gender and my artmaking
by constructing a feminist art practice that
encouraged—rather than discouraged—young
women from exploring their own experiences
as potential content for artmaking. (34)

———

I was marginalized for many decades because nobody could fit me into the narrow categories of contemporary art. When I was young, I wanted to fit in, but now [that] I'm old, I'm like, "I don't want to fit in." (43)

———

Because my work has aroused controversy, many people have made the assumption that I have courted controversy. Or set out to be provocative. Which is really not me at all. (30)

———

The core word in my work and in my life
is discovery. Discovery of this unknown
history; discovery of this unexpressed human
experience, birth; discovery of how immense
the Holocaust was and how immense its
effect was all over the world; discovery,
technical discovery—I love it. (30)

———

I watched [Anaïs Nin] respond to every
person who came up to her with a
combination of grace, sensitivity, and
compassion. And I've tried to bring those
same things to my interactions. (20)

———

Anything that is not masculinist appears
to people to have something to do with
identity—necessarily to do with identity—
even when it's not about identity. (42)

———

Who I am is the same person I've always been.
I have always had my own goals, and I never
thought about my own personal happiness.
What I wanted to do is be in my studio, and
in order to do that I had to give up things that
most women pursue, like happiness, balance,
boundaries, home, children, family, and
money. I didn't care about any of that. (45)

———

I was probably fortunate I didn't have a
strong desire to have a child, because I saw
what it did to so many women artists—how
it tore them apart. (6)

———

I would never [have been] able to have
the career I wanted if I had children. The
women artists I knew who did, even if they
did succeed, they felt guilty all the time.
They felt guilty when they were in their
studios. They felt guilty when they
were with their children. (22)

———

I have seen the careers of many women artists derailed by trying to "have it all," that is, a career, marriage, and a family. In my own case, it was clear to me from the time I was a young woman that, as unfair as it might be, this was not possible, at least not for women of my generation. (61)

———

I'm Jewish. I don't think it's biological; I think it's in the cultural upbringing. I also think my inclination toward social justice, egalitarian rather than authoritarian structures, sharing, educating comes directly from my [Jewish background]. (52)

———

I did a lot of study around the question,
"What does it mean to me to be a Jew?"
We were once Jews—slaves in Egypt—and
we became free, which leaves us with the
mandate to work for everyone's freedom. (20)

———

The horrific genocide and mass ethnic
cleansing we now see all over the world has
its roots in the Holocaust. I was interested in
why I knew so little about it. I was in my 40s,
I grew up in a political household, and even
though my parents were secular Jews, still I
came from a Jewish background—so why did
I not know anything about the Holocaust? (40)

———

Understanding mortality at such an early age gave me an impetus to work. One of the reasons I produced so much work is that I never knew how much time I would have. (45)

———

I think one of the things that actually makes life meaningful is the fact that it is gonna end.

(3)

———

We can't do anything about our own mortality, but we can definitely do something about what we're doing to the other creatures on the planet, and [to] the Earth. (51)

———

I feel incredibly privileged and grateful that I've lived in the 21st century, in America, at a time when on our planet there are a lot of women who can't go to school, who cannot work, who have to be covered up. They're deprived of sexual experience and pleasure. I'm unbelievably fortunate! (8)

———

I think it's very unseemly for privileged people like me to gripe. Yeah I've had a tough battle but you know what, the world's a tough place, the world's a tragic place. (8)

———

That's life—it's tough if you want to achieve or create anything of significance. (34)

———

One young woman asked me, didn't I think it was egocentric of me to be so concerned with my legacy. I told her no, that's what men have done their whole lives. (22)

———

I've never seen life as a popularity contest. (61)

———

I have a responsibility as an artist and as a person to try and make a difference, to try and make a contribution. I think that's what has been at the base of both my life, my work, and my decisions. So whatever I did, where I lived, how I lived was all a consequence of that, in order to accomplish that. (30)

———

Everyone could get a PhD in hindsight. (59)

———

I cannot imagine any other life than the one I've lived, one in which I've tried to make a contribution to art history, to increase opportunities for women, to pursue my own vision and to live as ethically as possible. (71)

———

For a long time, I didn't fit in, because nobody wanted to hear what I had to say. Now, if I do a public lecture, usually somebody in the back says, "Speak up, we can't hear you!" and I burst out laughing. For most of my career, people told me to shut up. (85)

———

I am not fearless. The problem with
that perception is that it separates me
from everyone else. (87)

———

I have lived the life I wanted to live and even
though it has often been difficult, I have no
regrets about the path I chose. (88)

———

I don't care if people get uncomfortable. (1)

———

I think believing in an afterlife relieves you
of responsibility to make something
important of your life now. (53)

———

My life is in my work. I'm boring. What's so interesting about me? It's my work. (30)

———

My art life has been more real to me than my real life. (1)

———

I didn't set out to curate my own shows and write my own books about my own work. It's just, nobody else would do it. (30)

———

My career is a kind of lesson plan for what it takes to push through the obstacles of those whose stories are not considered important.

(5)

———

Every day is a miracle. With what time I've got
left, I want to do what makes me happy. I'll
leave it to others to change the world. (40)

———

You never know what will happen if
you live long enough. (67)

———

I don't really easily fit into any of the existing
categories. I created my own career and
ad my own vision for art, and it's a
different vision. (77)

———

I'm Judy Chicago, and I'm an artist and
a troublemaker. (5)

———

Institutional Critique

There is so little art in our schools, because people have forgotten why art is important. (30)

———

I see [f]eminist art everywhere I travel by both male and female artists. The problem is that the institutions haven't caught up. (70)

———

One of the things I understood from early on was that art was a symbol of systemic inequity. The absence of women artists in our museums, or the marginalization of women in university curriculum, mirrors the everyday experience of women. (29)

———

Institutions aren't doing their job. That's how women's erasure continues. (22)

———

Art programs are not teaching young women about the history of the feminist art movement. They are not teaching them about the legacy of the seventies' Women's Building. ... The need is still there and the institutions are still failing. (13)

———

The art world has managed to convince everybody that there's been all this change in the last 10 years because there are so many shows of women. But shows are not the path to art history. (71)

———

Art history is shaped by permanent collections, major exhibitions and solo publications. In 1970, only 1.7% of solo art publications were devoted to women; today, over 40 years later, it is only 2.5%, so we are a long way from gender equity. (55)

———

Although my generation was able to change consciousness around gender, race, ethnicity, sexual orientation, etcetera, we have not been able to translate those changes into institutional change. Thus, we have seen how easily the changes can be rolled back. (78)

———

Between 2008 and 2018, in the US, only 11% of acquisitions at major museums have been works by women and only 3% have been women artists of colour; a shameful statistic and one that challenges the idea that the changes that have happened are substantive. (50)

———

[Women] should get 50 percent of the space in all institutions. That is what our mandate has to be. (13)

———

The job of institutions is to transmit culture and pass on the achievements of history so they can be built upon. When they don't, it's an institutional failure. (67)

———

The idea that gender matters must be translated into tangible institutional change. (61)

———

One of the problems of being raised within a particular paradigm is that the education of that particular paradigm is presumed to be universal and there is no alternative. (29)

———

I've seen examples of what not to do more often than I've seen examples of what to do. (13)

———

I do not have faith in the institutions as exist now to take care of my work. (30)

———

The status of Picasso indicates the degree to which even though there has been a change in consciousness, that change has not been translated institutionally. And that is where a lot of my efforts as an artist have been going, in terms of trying to make an institutional change. I think that until that happens, progress is ephemeral. (44)

———

A lot of women in positions of power have been as misogynous and as anti-female as men, maybe more so. For those of us who are interested in seeing a more equitable society, the issue isn't whether the person is a man or a woman, the issue is what kind of program they are putting forward. (44)

———

I'm a great critic of the university art curriculum, studio art curriculum. I think it has not been good for artists, who have become increasingly disconnected from the audience. (30)

———

Art school teaches you to talk in tongues, i.e., to make art that nobody can understand. I know what it's like. I went through the same process, and I deliberately set out to decode my work, my imagery, so people can understand it. I wanted my art to communicate. (46)

———

Art training is also inherently biased against women, because—I've worked with hundreds and hundreds of women, although this is a generalization—usually women are motivated by content, and since art school is focused on form, materials and concepts, it doesn't address female students' needs to learn how to translate their content into visual form. (46)

———

The history of feminist art is not integrated into our museums and universities and into the curriculum. So yes, it's inevitable that young women are going to waste a lot of time reiterating the same work that has been done before—and sometimes better—until that institutional change happens. (40)

———

Feminist art education begins with each person's individual voice and builds both individual and collaborative art-making out of those issues expressed by many different voices. Such an education can lead to a truly diverse art community and a more equitable world, which is what I still hope to see happen—and in my lifetime. (39)

———

Maybe you can't teach somebody to be an artist, but you can help people find their own voices, which is what I think art school ought to be focused on. It's another reason a lot of kids get stranded when they get out of school, because they haven't been helped to find their voice. (46)

———

A lot of young women are having a very difficult time in the art world because if their work is feminist or woman-centered, they're often marginalized. The exact freedom they need in order to make art that's powerful, effective, authentic is exactly what gets them into trouble with the art world. (52)

———

Women have to take off female shows from their résumés because it disqualifies them professionally. Did you know that? (30)

———

If you're going to have shows of women, they need to be grouped for other reasons than gender. Stylistic difference—similarities—thematic similarities, philosophical, kinship. (30)

———

Without meaning to, most of our educational institutions infantilize women. Although it is difficult for all students to make the transition from school to life, it is harder for most women students because, no matter how excellent their education, few of them are schooled in how to become independent; that is, feeling able to generate what they need for themselves rather than being dependent upon others. (88)

———

Young artists today aren't able to do what I did when I was young: work 60 hours a week in my studio. They have to have full-time jobs, they have to support themselves, and they have to pay off their debt. (40)

———

One of the things I'm interested in is whether or not we can demonstrate a different relationship between art and community, so that artists who live in a small town don't have to think, "I have to go to New York," or "I have to go to Los Angeles," or "I have to ignore my local town because I'm focused on the major art markets." (19)

———

You can learn a lot about what our society considers important and unimportant by what's missing, what isn't shown in museums and textbooks. It's images of birth, images about the Holocaust, images about slavery, truthful images about death. (22)

———

Men absolutely can't imagine what it's
like to grow up with the kind of absence
[women] grow up with. Absence of sculptures
in the parks. Absence of models of female
achievements. Absence in the halls of
government. Absence in the museums.
Absence! (22)

———

In the past four or five centuries, a number of
women artists became famous and successful
in their own time, only to have their work
subsequently ignored or deleted from the
historic record. This predicament raises an
unavoidable question: Will contemporary
women artists' success turn out to be as
fleeting as that of their predecessors? (61)

———

University studio art education needs
to be challenged or perhaps even completely
upended and replaced with something
new, something that allows art to be
reconnected with its true source, the human
spirit, which manifests itself in a wide
diversity of forms. (61)

———

Many feminist theorists argued that
the best way to subvert male art was by
critiquing it. To my mind, that simply keeps
male-centered art as the focus, which was not
a strategy that I was interested in. I wanted to
challenge and subvert the history of Western
civilization as it's taught, replacing male
heroes with female heroes. (93)

———

It is not enough for Women's Studies or Women in Art courses to exist as an adjunct— or antidote, as it were—to male-centered art and art history curricula. There must be a recognition that in terms of art education, we need to rethink what is being taught, what is most important to learn in order to become an effective artist, and the purposes for which our present art curriculum is geared. (84)

———

I view feminist art education as "empowerment education" because it begins with the process of helping students o become empowered to do what is important to them in their art. (39)

———

I believe that my circle methodology, which emphasizes that every voice is important, and an art education that focuses on content rather than form can be applied in a variety of ways and at a variety of levels and by people who aren't at all famous. (34)

———

No one dominates the class, including me. My role in class is that of facilitator. (39)

———

I see my role as helping [my students] to become prepared. If their feelings get hurt in the process, so be it; they'll discover soon enough that I'm a pussycat in comparison to whom and what they'll be up against in the art world. (34)

———

A woman can do a single thing—that's sort of an accident; but if she makes a coherent body of work[,] that means she has to be taken seriously in terms of ideas, and that moves into another place in the art world. (36)

———

Stay out of the market until you are sure you have found your own voice and your own compass that defines who your audience is and why you're making art. (40)

———

You have to move outside of the structure of the art world, because you don't get brownie points for telling men to fuck off. (36)

———

There is still considerable resistance to my work at an institutional level. (47)

Even though art has no gender, the art world seemed unable to accept me because of my gender. (51)

The galleries were very different when I was young than they are now. I mean, galleries believed in their artists. Exhibitions were shows; they weren't sales. (30)

I want my work accepted in the art world. But I've had to forge my own path, and I've had to be apart in order to do it. (30)

I'm a pragmatist. I'm not an elitist. (15)

———

Significant change can only occur if we shift
our focus to the work of those artists who
have had the courage to show us who
we are and what we are doing. (80)

———

Feminism and Social Impact

What is feminism? It is really challenging the male hegemony in the most fundamental way in terms of how we organize systems of learning, systems of behavior, what we value—everything. And that's why it's taking so long! (41)

———

Patriarchal society is built on the disempowerment of women. (52)

———

Feminism is about a different paradigm for the world that allows space for everybody. (9)

———

Patriarchy is a system of domination, and feminism is a system of collaboration. (6)

———

You don't have to be a man to support a patriarchal worldview, and you don't have to be a woman to support feminist values. (6)

———

What is not imaged does not exist—or is not valued. Thus, for there to be so few images of birth in Western art symbolizes that what women do is not important. Why should we be made to feel like that when— without us—the human race would cease to exist? (21)

———

The real damage that our culture has done to us is that we do not feel comfortable in the culture. We do not feel that we can be ourselves. We do not feel that we can make images of breasts, or images of wombs, or images of brutalization, or images of birth, without being laughed at, without being put down, without being ridiculed. (57)

———

Whereas men generally see their bodies as objects to be built up, strengthened, used, and exercised, women are often horrified about developing muscles that will defeminize them. (32)

———

I cannot tell you how deep is the sense of worthlessness in our psyches because we have been made to believe that women have never done anything valuable, and that any woman who tries is a freak. (17)

———

Suppression of anger in women leads to depression. It's an emotion that we should be allowed to express, just like vulnerability is a human condition that men should be allowed and are not. (45)

———

If we had a level playing field, women's work would just be seen as another form of expression. (26)

———

Art objects are value laden in that what is preserved and passed on shapes the future's view of reality. The fact that—for so many centuries—white male, Eurocentric art has been dominant reflects the larger political and social reality. (79)

———

If you talk about lack of power, victimization, marginalization, discrimination—the things women have experienced all over the planet in various forms—informed as it is by the intersectionality of where you live, what class you are, what race you are, you could say the female experience is more universal than the white, male, Eurocentric experience, right? The idea that a privileged, small class of artists and writers has been exploring and creating images and stories that are universal is actually quite ludicrous. (86)

———

A woman artist is still paid only 47½ cents of what a male artist gets when a work is sold, and auction prices continue to be even more inequitable. This reflects the larger social fact that around the world, what women do—in or out of the arts—is either not valued at all or valued less. (21)

———

I wanted to do what no woman has ever done, and that is to transcend my femaleness—to ascend to a level of human identity that women have been unable to reach because they are frozen into the roles of women as enumerated by a patriarchal social structure.

(38)

———

I am trying to make art that relates to
the deepest and most mythic concerns of
humankind and I believe that, at this moment
of history, feminism is humanism. (18)

———

As long as divinity is assumed to be male,
women will always be lesser. (77)

———

The goal is not to have female priests
worshipping a male god. The goal is to expand
our concept of the divine to include both
male and female. (77)

———

I think one of the real setbacks in the women's movement was that women were more willing to raise their daughters as feminists than to teach their sons another way of being men. (29)

———

Toxic masculinity is now a global phenomenon. It's a function of patriarchal control, and it's a way—you can call it mass terrorism—of keeping women in line. (60)

———

Men are so often brought up to think that what is womanly is despicable, and to be vulnerable is somehow to be unmanned. (77)

———

I don't hate men. I just want them to make space for women's points of view. (64)

———

Patriarchy is not the only way society has been organized. (6)

———

Our sexual identities are very basic to our whole perception of the nature of reality. To change that basic ordering of things, to reevaluate what it is to be a man and what it is to be a woman, actually leads you into a reevaluation of everything. (36)

———

In order to make a change, I think one has to have a really long historic view and understand that people don't give up power voluntarily. (7)

———

Women in the Middle Ages had more power than women in the Renaissance, and things did not get better and better for women, they got better and better for men. (17)

———

Men see themselves, their past, and their achievements and that shapes their self-image. It's really difficult for women to do the same thing with the absence of a history. (26)

———

The real crux of chauvinism in art and history is that we as women have learned to see the world through men's eyes and learned to identify with men's struggles, and men don't have the vaguest notion of identifying with ours. (36)

———

As women, we've been negative space
for most of history. (22)

———

Women do not know what women before
them thought and taught. As a result, women
are caught in a cycle of repetition. They go
through life experiences that others have had
and theorized about without being able to
build upon those theories. That is why
feminism is important. (83)

———

Since I learned so much from male art,
I always believed that men could learn
from feminist art. Why not? (64)

Feminist art teaches us that the basis of
our culture is grounded in a pernicious
fallacy—a fallacy which causes us to believe
that alienation is the human condition and
real human contact is unattainable. (82)

———

I get so furious with that whole period
in feminist theory that announced that desire
was male; genius was male. Why should men
have a corner on the market of any aspect
of human aspiration? Why shouldn't
women have the right to any aspect
of human aspiration? (30)

———

Aspiration is tied up with male achievement. (30)

———

The entire class struggle is based on the division between male and female—and that is what, for me, is fundamental. (17)

———

Power is the thing that women have been taught is a real taboo. (48)

———

The LA art scene in the 1960s was unbelievably macho. I was the only woman taken seriously, and even then I was kind of marginal. There is even ongoing resistance today. (28)

———

In the sixties, one of the common things I was told all the time is, "You can't be a woman and an artist too." (4)

———

It's no accident that it was during this whole period when I was least overt about my womanliness—1965—that I made my reputation as an artist. (36)

———

I was not the "only woman in the art world"; rather, I was the only woman taken seriously in the LA art scene of the 1960s and '70s. There were lots of women but they were marginalized. (50)

———

When I was young in LA, artists used to refer to any strong woman like Louise Nevelson as a bitch—and when I saw Megan Thee Stallion in a rap video talk about how she was a bitch, I thought here is a woman taking control of her identity and also taking control of some of the ways women have been diminished in the same way I tried to turn around the term "cunt." (45)

———

It took me a decade to realize that even if I didn't want to identify as a woman, the world saw me as a woman, and the various responses in the art world were definitely shaped by the world's attitudes toward women. I learned it was a better strategy to accept reality rather than to try to deny it. (40)

———

I do not think that the *Holocaust Project* is any less feminist than *The Dinner Party*. (41)

———

Sexism is really not a woman's problem. It's men's problem. Men are sexist. Men are disfigured by sexism and men are the ones who are standing in the way of women. (63)

———

The idea of feminists as angry man haters has been promulgated by the media, which is not always truthful, especially those journalists who (consciously or unconsciously) support the patriarchal paradigm. (64)

———

What is "cunt"? We have definitions of ourselves by man. Cunt is passive; cunt is receptacle; cunt is vessel; cunt is giver of all rewards and blessings—mother; cunt is evil, demonic; [cunt] will swallow you up. Those are all projections, fantasy projections. (27)

———

We must unearth the buried and half-hidden treasures of our cunts and bring them into the light and let them shine and dazzle and become Art. We must recover our history, rebuild our humanity, and reconstruct our community. Only then will we make the art that we have the right to make. (32)

———

Unless one's own experience of oppression
helps one become a bigger person, I don't
want to hear about it. So you're oppressed?
Well, join the group. Let's join hands and
end oppression in the world. (52)

———

My idea of feminism is a revolutionary
transformation of the planet. When people
talk about living in a "post-feminist" world,
I just laugh. Post-feminist for whom?
For some small segment of the population
in a few countries. But for everyone
else, hardly. (52)

———

My definition of feminism has also expanded
to include all those who are hurt by the
patriarchal paradigm—both human
and non-human. (21)

———

A lot of women artists believe that everything
has changed. I don't believe that that is true.
(11)

———

Look at what's happened with the pandemic
in terms of women and their work. I mean,
why is anybody surprised? What women do
doesn't count. It doesn't matter if it's child
care, housework, or making art. (10)

———

My original goal was for feminist art to become global, which has happened. It is thrilling to me to see women artists all over the world expressing themselves openly as women, which was impossible when I was young. (47)

———

I think [Instagram has] been an incredible platform for women, especially in parts of the world that are more closed-off. It's like a portal. (22)

———

I think that most feminists are interested in remaking the world, in new terms. It is not that we don't want to work with men; we just won't let men work with us in the old way.

(17)

———

Women today are awakening all over the globe, and they don't want to be objectified anymore. They don't want to be the object of the male gaze. They want the right to make their own decisions. (1)

———

Feminism has grown in terms of our concept of intersectionality and the overlap of multiple identities, and I think it has to grow to encompass all living creatures. (10)

———

Look at the natural environment. Be there. Look at it. Watch beauty unfold in it. And hopefully that will help transform human consciousness so that we change course and become stewards of the incredible landscape that gives us life instead of destroying it. (59)

———

Feminism is all about values. You don't have
to be a woman to be a feminist. (13)

———

Only by exposing the most truly human
inside us will we be able to reach across
and bridge the terrible gap between
men and women. (36)

———

It is both a privilege & a pain in the ass to
have been born a woman at this time in
History—a privilege because we may change
History—a pain in the ass because I'd like
to be FREE! (38)

———

I've spent my whole life fighting for what
I feel is right. It's given my life meaning,
and I hope it's given some insights
to other people. (8)

———

My goal has always been to make a
contribution, a goal that has never changed.
(47)

———

You have to choose hope. Hope comes
from feeling that you're on the side of
right and fighting for it. If you're a passive
observer to what's going on, it's
easy to give in to despair. (8)

———

Change has to be made brick-by-brick. (22)

———

What if women ruled the world? (1)

———

Feminism is about working for a different world, not just for our own liberation. (38)

———

SOURCES

1. Chicago, Judy. "Judy Chicago: Making Change." Fine Arts Museum of San Francisco. Published on October 6, 2021. Video, 9:18. https://www.youtube.com/watch?v=D9 _wIu8ePxs.

2. Chicago, Judy. *Judy Chicago: A Retrospective*. De Young Museum. https://deyoung.famsf.org/exhibitions/judy-chicago.

3. Chicago, Judy. "Judy Chicago, Founding Mother of Feminist Art." *CBS Sunday Morning*, January 2, 2022. Video, 6:53. https://www.youtube.com/watch?v=kNgsSlnmnMA.

4. Chicago, Judy. "Judy Chicago on *Womanhouse*." National Museum of Women in the Arts, September 13, 2017. Video, 35:53. https://www.youtube.com/watch?v=Z9muNnozFGY.

5. Chicago, Judy. "Judy Chicago—'I'm an Artist and a Troublemaker.'" Tate, June 30, 2017. Video, 6:01. https://www.youtube.com/watch?v=NlH85Kgdnq0.

6. Chicago, Judy. "Brooklyn Talks: Maria Grazia Chiuri and Judy Chicago." Brooklyn Museum, September 10, 2021. Video, 54:07. https://www.youtube.com/watch?v=w3aG9NfY6Ac.

7. Chicago, Judy. "Judy Chicago." Art Basel, June 7, 2019. Video, 1:05:51. https://www.youtube.com/watch?v=0wSfg4OICW4.

8. Chicago, Judy. "'You Have to Choose Hope'—An Interview with Judy Chicago." Interviewed by Jonathan Griffin. *Apollo*, February 3, 2019. https://www.apollo-magazine.comyou-have-to-choose-hope-an-interview-with-judy-chicago/.

9. Chicago, Judy. "Meet the Artists | Judy Chicago | The Birth Project." Art Basel, January 9, 2019. Video, 5:50. https://www.youtube.com/watch?v=O8ouH6zhI_8.

10. Chicago, Judy. "As She Prepares to Release Her Autobiography, Judy Chicago Reflects on What It Takes to Preserve an Artistic Legacy." Interview by Arden Fanning Andrews. *Artnet News*, March 24, 2021. https://news.artnet.com/art-world/judy-chicago-interview-1952343.

11. Weiss, Sasha. "Judy Chicago, the Godmother." *New York Times Style Magazine*, February 7, 2018. https://www.nytimes.com/2018/02/07/t-magazine/judy-chicago-dinner-party.html.

12. Chicago, Judy. "Judy Chicago Confronts Her Younger Self." Interviewed by Andrea Whittle. *W Magazine*, January 21, 2022. https://www.wmagazine.com/culture/judy-chicago-biography-feminist-art-interview.

13. Chicago, Judy. "Judy Chicago and Jane Gerhard: Art Education and Popular Feminism | Radcliffe Institute." Harvard University, March 10, 2014. Video, 1:09:27. https://www.youtube.com/watch?v=bBuR47_WwFQ.

14. Chicago, Judy. "Judy Chicago: Is There a 'Female Aes-
 thetic'?" SFMOMA. Video, 4:25. https://www.sfmoma
 .org/watch/judy-chicago-female-aesthetic/.

15. Chicago, Judy. "Interview with Judy Chicago." Interviewed
 by Judith Dancoff. *Everywoman* 2, no. 7 (1971): 4–5.
 Archives of Sexuality and Gender.

16. Chicago, Judy. *Through the Flowers: My Struggle as a Woman
 Artist.* New York: Doubleday, 1975.

17. Butterfield, Jan. "Guess Who's Coming to Dinner? An
 Interview with Judy Chicago." *Mother Jones* 4, no. 1
 (January 1979).

18. "Judy Chicago." *Artnet.* http://www.artnet.com/artists
 /judy-chicago/.

19. Chicago, Judy. "An Interview with Judy Chicago."
 Interviewed by Jeffery Deitch. *Purple Magazine* 32 (Fall/
 Winter 2019). https://purple.fr/magazine/the-cosmos
 -issue-32/an-interview-with-judy-chicago/.

20. Chicago, Judy. "Judy Chicago Reflects on Prolific Artistic
 Career in New Memoir." Interviewed by Scott Simon.
 NPR, July 24, 2021. https://www.npr.org/2021/07/24
 /1020088190/judy-chicago-reflects-on-prolific-artistic
 -career-in-new-memoir.

21. Chicago, Judy. "An Interview with Judy Chicago,
 Feminist Art Pioneer." *Artspace*, August 8, 2019. https://
 www.artspace.com/magazine/interviews_features/qa

an-interview-with-judy-chicago-feminist-art-pioneer
-56182.

22. Kahn, Mattie. "Judy Chicago Never Wanted to Have It All."
Glamour, September 25, 2019. https://www.glamour.com
/story/judy-chicago-feminist-artist-interview.

23. Small, Rachel. "'It Happens': Breaking Glass with
Judy Chicago." *Interview*, January 5, 2022. https://www
.interviewmagazine.com/art/it-happens-breaking-glass
-with-judy-chicago.

24. Chicago, Judy. "Artist Interview: Judy Chicago." Tate,
September 2015. https://www.tate.org.uk/whats-on
/tate-modern/world-goes-pop/artist-interview/judy
-chicago.

25. Chicago, Judy. "Judy Chicago Is Tired of *The Dinner Party*."
Interviewed by Sangeeta Singh-Kurtz. *The CUT*, December
7, 2021. https://www.thecut.com/2021/12/judy-chicago
-on-her-glass-show-death-and-the-dinner-party.html.

26. Chicago, Judy. "Judy Chicago: 'Get Used to It!'" *The Talks*.
https://the-talks.com/interview/judy-chicago/.

27. Chicago, Judy. "Judy Chicago on C*nt." YouTube video,
1:33. Published on November 13, 2010. https://www
.youtube.com/watch?v=XRCtUbSeorI.

28. Chicago, Judy. "Chicago Is Everywhere." Interviewed by
Todd Plummer. *Interview*, April 14, 2014. https://www.
interviewmagazine.com/art/judy-chicago-chicago-in-la
-a-butterfly-for-brooklyn.

29. Chicago, Judy. "Feminist Art Icon Judy Chicago Isn't Done Fighting." Interviewed by Gloria Steinem. *Interview*, December 11, 2017. https://www.interviewmagazine .com/art/feminist-art-icon-judy-chicago-isnt-done -fighting.

30. Chicago, Judy. "Oral History Interview with Judy Chicago, 2009 August 7–8." Interviewed by Judith Richards. *Smithsonian Archives of American Art*. https://www.aaa.si.edu download_pdf_transcript/ajax?record_id=edanmdm -AAADCD_oh_283567.

31. Riefe, Jordan. "At 80, Judy Chicago Reaches Her Prime." *Art & Object*, August 27, 2019. https://www.artandobject .com/news/80-judy-chicago-reaches-her-prime.

32. Gerhard, Jane. "Judy Chicago and the Practice of 1970s Feminism." *Feminist Studies* 37, no. 3, Feminist Histories and Institutional Practices (Fall 2011): 591–618. https:// www.jstor.org/stable/23069923.

33. Chapman, Frances. "Judy Chicago: Vaginal Iconographer." *off our backs* 5, no. 6 (July 1975): 16–17. https://www .jstor.org/stable/25772278.

34. Keifer-Boyd, Karen. "From Content to Form: Judy Chicago's Pedagogy with Reflections by Judy Chicago." *Studies in Art Education* 48, no. 2 (Winter 2017): 134–54. https://www .jstor.org/stable/25475816.

35. Røstvik, Camilla Mørk. "Blood Works: Judy Chicago and Menstrual Art Since 1970." *Oxford Art Journal* 42, no. 3 (December 2019): 335–53.

36. Chicago, Judy. "Judy Chicago Talking to Lucy R. Lippard." *Artforum* 13, no. 1 (September 1974). https://www.artforum.com/print/197407/judy-chicago-talking-to-lucy-r-lippard-37354.

37. Chicago, Judy. "Two Artists, Two Attitudes: Judy Chicago and Lloyd Hamrol Interview Each Other." *Criteria: A Review of the Arts* 1, no. 2 (November 1974): 9.

38. Gail, Levin. *Becoming Judy Chicago: A Biography of the Artist.* New York: Harmony Books, 2007.

39. Chicago, Judy. "Feminist Art Education: Made in California." In *Entering the Picture: Judy Chicago, the Fresno Feminist Art Program, and the Collective Visions of Women Artists.* Edited by Jill Fields. New York: Taylor & Francis, 2012.

40. Chicago, Judy. "I'll Leave It to Others to Change the World." Interviewed by Anna McNay. *Studio International.* Published December 9, 2015. https://www.studiointernational.com/index.php/judy-chicago-interview-world-goes-pop-tate-modern.

41. Chicago, Judy. "Of Vulvas and Car Hoods: William J. Simmons Interviews Judy Chicago." *Big Red and Shiny,* May 19, 2014. https://bigredandshiny.org/1760/of-vulvas-and-car-hoods-william-j-simmons-interviews-judy-chicago/.

42. Chicago, Judy. "Interview with Judy Chicago." Interviewed by Lynn Hershman. November 9, 1990. https://purl .stanford.edu/pb068pv1300.

43. Lloyd-Smith, Harriet. "'I Just Didn't Fit': Feminist Icon Judy Chicago on Revolutionizing Art History." *Wallpaper**, December 31, 2021. https://www.wallpaper.com/art /judy-chicago-interview-de-young-museum -retrospective.

44. Whitehead, John W. "Women and Art: An Interview with Judy Chicago." *Gadfly*, November/December 1999. http://www.gadflyonline.com/home/archive/NovDec99 /archive-judychicago.html.

45. Rosen, Miss. "Judy Chicago on Setting the Patriarchal Art World Ablaze." *Dazed*, July 23, 2021. https://www .dazeddigital.com/art-photography/article/53616/1 judy-chicago-art-world-patriarchy-interview-the -flowering-book-memoir.

46. Allmer, Patricia. "Judy Chicago—on Teaching Artists." *Cassone*, August 2011. http://www.cassone-art.com /magazine/article/2011/08/judy-chicago-on-teaching -artists/?psrc=interviews.

47. Quinn, Bridget. "Judy Chicago in Her Own Words." *Alta*, September 27, 2021. https://www.altaonline.com /culture/art/a37416742/judy-chicago-in-her-own -words/.

48. Chicago, Judy. "Interview with Judy Chicago." Interview by Ann Stubbs. WBAI, September 12, 1985. https://archive.org/details/pra-IZ1161.

49. Chicago, Judy. *Through the Flower: My Struggle as a Woman Artist*. New York: Anchor Books, 1977.

50. Mara de Wachter, Ellen. "Judy Chicago: The Fight for Gender Equality Is Not Over." *Frieze*, November 25, 2019. https://www.frieze.com/article/judy-chicago-fight-gender-equality-not-over.

51. Judah, Hettie. "Judy Chicago's Extinction Rebellion: 'I Went Face-to-Face with a New Level of Horror.'" *Guardian*, November 27, 2019. https://www.theguardian.com/artanddesign/2019/nov/27/judy-chicago-interview-extinction-rebellion.

52. Strong, Lester. "Painting a Revolution: A Talk with Judy Chicago on Art, Gender, Feminism, and Power." *International Journal of Sexuality and Gender Studies* 7, no. 4 (October 2002): 307–25.

53. Chicago, Judy. "Interview with Judy Chicago Conducted at the National Museum of Women in the Arts." *Veils of Teeth*, September 16, 2019. https://veilsofteeth.com/in-conversation/judy-chicago/.

54. Gauthier, Olivia. "Toxic Masculinity and Rainbows: Judy Chicago Interviewed by Olivia Gauthier." *Bomb*, March 1, 2018. https://bombmagazine.org/articles/toxic-masculinity-and-rainbows-judy-chicago-interviewed/.

55. Simmons, William. "Singing *Songs*: Revisiting Feminism and the Politics of Memory." In *Notes Magazine*, 2014.

56. Chicago, Judy, and Claudia Schmuckli. "Decades of Powerful Art Emerge from the Shadow of *The Dinner Party* in DeYoung's Judy Chicago Retrospective." By Alexis Madrigal. KQED, December 10, 2021. https://www.kqed .org/forum/2010101886860/decades-of-powerful-art -emerge-from-the-shadow-of-the-dinner-party-in -deyoungs-judy-chicago-retrospective.

57. Nin, Anaïs. "An Evening with Anaïs Nin." Interview by Judy Chicago. KPFK, February 15, 1972. https://archive .org/details/pacifica_radio_archives-BC0619B.

58. Chicago, Judy. *The Dinner Party: From Creation to Preservation*. New York: Merrell, 2007.

59. Vankin, Deborah. "Judy Chicago on Her Desert X Smoke Sculpture and Feminizing Land Art." *Los Angeles Times*, February 18, 2021. https://www.latimes.com /entertainment-arts/story/2021-02-18/judy-chicago -desert-x-land-art-living-desert.

60. Tindle, Hannah. "Radical Artist Judy Chicago on Pyrotecnics and Toxic Masculinity." *AnOther*, November 27, 2018. https://www.anothermag.com/art-photography/11335/ radical-artist-judy-chicago-on-pyrotechnics-and-toxic- masculinity.

61. Chicago, Judy. *Institutional Time: A Critique of Studio Art Education*. New York: Monacelli Press, 2014.

62. Bischof, Felix. "Judy Chicago Interview: Dior Lady Art 5." *The Week*, December 8, 2020. https://www.theweek.co.uk/108866/dior-lady-art-5-judy-chicago-interview.

63. "Party Like It's 1979: Interview with Judy Chicago." *Art Dependence*, September 27, 2015. https://www.artdependence.com/articles/party-like-it-s-1979-interview-with-judy-chicago/.

64. Benoit, Raina. "Feminist Mythmakers in the Age of Ambivalence: An Interview with Judy Chicago." *Temporary Art Review*, April 11, 2016. https://temporaryartreview.com/feminist-mythmakers-in-the-age-of-ambivalence-an-interview-with-judy-chicago/.

65. Barnes, Freire. "Judy Chicago Interview." *Timeout*, September 9, 2015. https://www.timeout.com/london/art/judy-chicago-interview.

66. Kaminer, Michael. "Worldwise: Artist Judy Chicago's Favorite Things." *Penta*, March 23, 2022. https://www.barrons.com/articles/worldwise-artist-judy-chicagos-favorite-things-01648052918.

67. Chicago, Judy. "Interview with Paige K. Bradley." *Artforum*, March 28, 2014. https://www.artforum.com/interviews/judy-chicago-on-her-nationwide-retrospective-and-latest-book-45961.

68. Csernyik, Rob. "Artist Judy Chicago Brings the Smoke to Toronto Biennial of Art." *Maclean's*, June 2, 2022. https://

www.macleans.ca/culture/artist-judy-chicago-brings-the
-smoke-to-toronto-biennial-of-art/.

69. Stromberg, Matt. "Judy Chicago's California Comeback."
 C Magazine, Spring 2020. https://magazinec.com/culture
 /judy-chicago-california-comeback/.

70. "Judy Chicago Birthday: Celebrating the Feminist Art
 Pioneer." *HuffPost*, July 20, 2013. https://www.huffpost
 .com/entry/judy-chicago-birthday_n_3623420.

71. Jothianandan, Shakthi. "What Artist Judy Chicago Can't
 Live Without." *Wall Street Journal*, April 24, 2020. https://
 www.wsj.com/articles/what-artist-judy-chicago-cant-live
 -without-11587731309.

72. Chicago, Judy. "Questionnaire." *Frieze*, no. 176 (January–
 February 2016): 160. https://judychicago.arted.psu.edu
 /wp-content/uploads/2013/04/Frieze-Judy-Chicago
 -interview.pdf.

73. Miranda, Carolina A. "Judy Chicago Says, 'I Was Being
 Erased' from Southern California Art History." *Los Angeles
 Times*, September 6, 2019. https://www.latimes.com
 /entertainment-arts/story/2019-09-06/judy-chicago
 -beyond-the-dinner-party-feminist-art-jeffrey-deitch
 -los-angeles.

74. Mahler, Richard. "The Battle of Chicago: Art: Feminist
 Artist Judy Chicago Fires Back at Critics Who Call Her
 'Dinner Party' Obscene and Withdraws Her Gift of It to a

University." *Los Angeles Times*, October 12, 1990. https://
www.latimes.com/archives/la-xpm-1990-10-12-ca-2100
-story.html.

75. Kennicott, Philip. "Can Judy Chicago Make D.C. Her Sister
City?" *Washington Post*, January 17, 2014. https://www
.washingtonpost.com/entertainment/museums/can
-judy-chicago-make-dc-her-sister-city/2014/01/17
/cf7d1d14-7d56-11e3-95c6-0a7aa80874bc_story.
html?itid=lk_interstitial_manual_8.

76. Grisar, PJ. "How Judy Chicago Became Part of Art History."
Forward, July 14, 2021. https://forward.com/culture
/472889/judy-chicago-the-flowering-retrospective
-the-dinner-party-jewish-holocaust/.

77. Binlot, Ann. "Judy Chicago's 1983 Sketches Still Threaten
the Patriarchy." Interview by Nancy Princenthal. *Document
Journal*, April 30, 2020. https://www.documentjournal.
com/2020/04/judy-chicagos-1983-sketches-still-threaten
-the-patriarchy/.

78. Reagan, Caroline. "Judy Chicago Illustrates a Cautionary
Tale for Our Post-COVID Future." Interview by Hannah
Ongley. *Document Journal*, May 27, 2020. https://www
.documentjournal.com/2020/05/judy-chicago-illustrates
-a-cautionary-tale-for-our-post-covid-future/.

79. Dolle, Coco. "Cultural Rebels: The Art of Defiance; Judy
Chicago in Conversation with Coco Dolle." *Whitehot*

Magazine, December 2020. https://whitehotmagazine
.com/articles/in-conversation-with-coco-dolle/4805.

80. Chicago, Judy. "What Does Art Have to Do with the
Coronavirus?" *New York Times*, May 28, 2020. https://
www.nytimes.com/2020/05/28/opinion/art-social
-change.html.

81. Chicago, Judy. "We Women Artists Refuse to Be Written
Out of History." *Guardian*, October 9, 2012. https://www
.theguardian.com/commentisfree/2012/oct/09/judy
-chicago-women-artists-history.

82. Chicago, Judy. "What Is Feminist Art?" https://www
.judychicago.com/wp-content/uploads/2015/07
/what-is-feminist-art.pdf.

83. Chicago, Judy. "Why Study Feminism?" https://www
.judychicago.com/wp-content/uploads/2015/07/why
-study-feminism.pdf.

84. Chicago, Judy. "Feminist Art Education: Made in Califor-
nia." https://www.judychicago.com/wp-content/uploads
/2015/07/made-in-california.pdf.

85. Diderich, Joelle. "Judy Chicago Reunites with Dior for
Handbag Project." *Paris Special Edition*, October 1, 2020.
https://www.judychicago.com/wp-content/
uploads/2020/10/WWD-2020-10-01-2-1.pdf.

86. Hegert, Natalie. "*Potent Pussy*: Judy Chicago." *The Seen*,
May 23, 2017.

87. Chicago, Judy. "Amplify—Judy Chicago." National Museum of Women in the Arts, October 30, 2017. Video, 1:18:27. https://www.youtube.com/watch?v=iq-hTxQ3GDs&list=PL1boWZ4URBmr-ycItCeoqFrBnnPlVQ4wP&index=2.

88. Chicago, Judy. "Commencement Address." Smith College, May 14, 2000. https://www.smith.edu/about-smith/smith-history/commencement-speakers/2000.

89. Chicago, Judy. "Judy Chicago's Advice to Artists." Institute of Contemporary Art, Miami, January 24, 2019. Video, 1:19. https://www.youtube.com/watch?v=xDFR6CHc8y0.

90. Siegler, Mara. "Artist Judy Chicago on Her Career, Advice for Young Women." *Page Six*, December 8, 2018. https://pagesix.com/2018/12/08/artist-judy-chicago-on-her-career-advice-for-young-women/.

91. Papanicolaou, Christina. "In Her Own Hand: Judy Chicago's Use of Text in *The End*." *NMWA*, December 19, 2019. https://nmwa.org/blog/nmwa-exhibitions/in-her-own-hand-judy-chicagos-use-of-text-in-the-end/.

92. Obrist, Hans Ulrich. "In Conversation with Judy Chicago." In *Judy Chicago: New Views*. Edited by Elizabeth Lynch, 19–28. New York: Scala Arts, 2019.

93. Hermo, Carmen. "Judy Chicago in Conversation." In *Judy Chicago: Roots of the Dinner Party*. Edited by David Colman, 21–26. New York: Salon 94, 2018.

94. Schmuckli, Claudia. "The Process of Empathy: An Interview with Judy Chicago." In *Judy Chicago: In the Making*. Edited by Jane Friedman with Victoria Gannon, 17–32. San Francisco: Fine Arts Museum of San Francisco de Young, 2021.

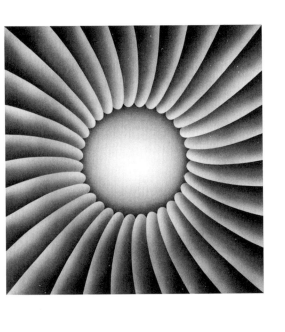

CHRONOLOGY

This chronology has been adapted primarily from the chronology included in *Judy Chicago: New Views*, published by the National Museum of Women in the Arts and Scala Arts & Heritage in 2019.

1939

July 20: Judy Chicago (née Judith Sylvia Cohen) is born in Chicago, Illinois. Her father, Arthur, was a labor organizer and Marxist, and her mother, May, was a medical secretary and former dancer.

1945

Due to Chicago's father's involvement in the American Communist Party, an FBI agent visits the home while her parents are away but is interrupted when her mother returns.

1947

Chicago begins to attend classes at the Art Institute of Chicago.

1953

Arthur Cohen passes away from peritonitis when
 Chicago is thirteen years old.

1957

Chicago enrolls at UCLA, where she receives her BA
 (1962) and MA (1964).

1961

Chicago marries Jerry Gerowitz.

1963

Jerry Gerowitz dies in a car accident.

1966

Chicago has her first solo exhibition at Rolf Nelson
 Gallery in Los Angeles.
Rainbow Pickett is shown in the exhibition *Primary
 Structures* at the Jewish Museum in New York.

1967

10 Part Cylinders is shown in the exhibition *American Sculpture of the Sixties* at the Los Angeles County Museum of Art.

1968–74

Chicago experiments in altering environments with *Atmospheres*, her series of works in flares, fireworks, and smoke.

1970

Chicago has a solo exhibition at California State University, Fullerton, which debuts the sprayed-lacquer series *Pasadena Lifesavers*.

She legally changes her name to Judy Chicago, which she announces in an ad for her Fullerton exhibition in the October issue of *Artforum*. She also poses in a boxing ring for an iconic ad in the December issue of *Artforum*.

Chicago joins the faculty at California State University, Fresno (Fresno State), where she founds the Feminist Art Program.

1972

Chicago moves the Feminist Art Program to the California Institute of the Arts (Cal Arts), where she team teaches with Miriam Shapiro. They lead the women in the program in creating the installation *Womanhouse*.

1974–79

Chicago creates *The Dinner Party*, an installation focused around a triangular table with thirty-nine ceremonial place settings, as a symbolic history of women in Western civilization. She leads a team of hundreds of volunteers, including needleworkers, designers, and researchers.

1975

Chicago publishes the memoir *Through the Flower: My Struggle as a Woman Artist*, with an introduction by Anaïs Nin.

1979

The Dinner Party premieres at the San Francisco Museum of Modern Art before traveling to many other venues in a grassroots exhibition tour.

1980–85

Chicago works on the *Birth Project*, a series of painted and needleworked images of creation, birth, and pregnancy. The works are shown at more than one hundred venues beginning in 1982.

1982–87

Chicago creates *PowerPlay*, a series of drawings, paintings, sculptures, and weavings that examines the construct of masculinity.

1985

Chicago marries photographer Donald Woodman.

1985–93

With Woodman, she works on the *Holocaust Project: From*

Darkness into Light, a multimedia series exploring the Holocaust, which premieres in 1993 at the Spertus Museum in Chicago before traveling to museums across the country.

1994–2000

Chicago creates *Resolutions: A Stitch in Time*, a series of painted and needleworked images reinterpreting traditional proverbs, which is organized by the Museum of Arts and Design in New York and debuts in 2000 at the American Craft Museum in New York before traveling to several other venues.

1996

Chicago's personal archives are housed at the Arthur and Elizabeth Schlesinger Library on the History of Women in America at the Radcliffe Institute for Advanced Study at Harvard University.

Chicago publishes the memoir *Beyond the Flower: The Autobiography of a Feminist Artist*.

1997

Solo exhibition: *Judy Chicago*, Hanart Gallery, Taipei, Taiwan.

1999–2004

Chicago creates the watercolor series *Kitty City*, which is
published in 2005 in the book *Kitty City: A Feline Book
of Hours*.

2001

Solo exhibition: *Judy Chicago*, Fitzwilliam Museum,
Cambridge, UK.

2002

The Elizabeth A. Sackler Foundation acquires *The Dinner
Party*, with the intention of permanently housing it as
the centerpiece of the Elizabeth A. Sackler Center for
Feminist Art at the Brooklyn Museum, New York.
Solo exhibition: *The Dinner Party*, Brooklyn Museum,
New York.
Solo exhibition: *Judy Chicago*, National Museum of
Women in the Arts, Washington, DC.

2006

The exhibition *Chicago in Glass*, a survey of Chicago's
two- and three-dimensional works in glass, opens
at LewAllen Contemporary, Santa Fe, New Mexico.

2007

The Dinner Party opens in its permanent installation at
the Brooklyn Museum, New York.

Chicago's work is included in the exhibition *WACK! Art
and the Feminist Revolution*, which opens at the Los
Angeles Museum of Contemporary Art and travels
to the National Museum of Women in the Arts,
Washington, DC; MoMA PS1, New York; and the
Vancouver Art Gallery, Canada.

Solo exhibition: *Judy Chicago: Jewish Identity*, Hebrew
Union College Art Museum, New York.

Solo exhibition: *Birth Project*, Albuquerque Museum,
New Mexico.

2007–13

Chicago creates *Heads Up*, a series of heads in watercol-

ors, sketches, two-dimensional painted glass, three-dimensional cast glass, and ceramic, which debuts in 2014 at David Richard Gallery, Santa Fe, New Mexico.

2010
Chicago publishes *Face to Face: Frida Kahlo* with Frances Borzello,

2011
Penn State University acquires Chicago's art education archive.

Her work is included in eight museum group exhibitions as part of *Pacific Standard Time*, a Getty-funded initiative on the art of Southern California. She also has three solo exhibitions in Los Angeles.

Solo exhibition: *Judy Chicago Tapestries: Woven by Audrey Cowan*, Museum of Arts and Design, New York.

2012
Solo exhibition: *Judy Chicago*, Riflemaker, London.

Solo exhibition: *Judy Chicago: And Louise Bourgeois, Helen*

Chadwick, Tracey Emin, Ben Uri, London Jewish Museum of Art.

Solo exhibition: *Judy Chicago: Deflowered*, Nye + Brown, Culver City, California.

2013

Solo exhibition: *Judy Chicago*, Frieze Masters, London.

Solo exhibition: *Judy Chicago: Deflowered*, Oslo Kunst-forening, Norway.

2014

Museums around the United States hold exhibitions in honor of Chicago's seventy-fifth birthday.

Chicago stages the pyrotechnic performance piece *A Butterfly for Brooklyn* in Brooklyn's Prospect Park, New York.

2014

Chicago publishes *Institutional Time: A Critique of Studio Art Education*.

Solo exhibition: *Chicago in L.A.: Judy Chicago's Early Work*,

1963–74, Elizabeth A. Sackler Center for Feminist Art, Brooklyn Museum, New York.

Solo exhibition: *Judy Chicago: Circa '75*, National Museum of Women in the Arts, Washington, DC.

Solo exhibition: *Judy Chicago: Through the Archives*, Arthur and Elizabeth Schlesinger Library on the History of Women in America, Cambridge, Massachusetts.

Solo exhibition: *Local Color: Judy Chicago in New Mexico, 1984–2014*, New Mexico Museum of Art, Santa Fe.

Solo exhibition: *Surveying Judy Chicago: 1970–2014*, RedLine Contemporary Art Center, Denver, Colorado.

2015

Solo exhibition: *Star Cunts and Other Images*, Riflemaker, London.

Solo exhibition: *Why Not Judy Chicago?*, Azkuna Zentroa, Bilbao, Spain, and CAPC musée d'art contemporain de Bordeaux, France.

2016

Chicago stages *Be No More*, an installation made with dry

ice and flares, at the San Francisco Museum of
Modern Art.

Solo exhibition: *Born Again: Judy Chicago's Birth Project*,
Museum of Fine Arts, Florida State University,
Tallahassee.

2017

The National Museum of Women in the Arts announces
the establishment of the Judy Chicago Visual Archive.

Chicago designs *Four Lads from Liverpool*, a mural commis-
sioned by Tate Liverpool, as part of the "Sgt. Pepper
at 50" celebration, Liverpool, UK.

Solo exhibition: *Inside the Dinner Party Studio*, National
Museum of Women in the Arts, Washington, DC.

Solo exhibition: *Judy Chicago's Pussies*, Jessica Silverman
Gallery, San Francisco.

Solo exhibition: *Roots of the Dinner Party: History in the
Making*, Brooklyn Museum, New York.

2018

Solo exhibition: *Judy Chicago: A Reckoning*, Institute of
Contemporary Art, Miami, Florida.

Solo exhibition: *PowerPlay: A Prediction*, Salon 94,
 New York.

2019
Solo exhibition: *The End: A Meditation on Death and
 Extinction*, National Museum of Women in the Arts,
 Washington, DC.
The Judy Chicago Research Portal is launched. The online
 portal is hosted by Penn State University, the National
 Museum of Women in the Arts, and the Arthur and
 Elizabeth Schlesinger Library on the
 History of Women in America.
Solo exhibition: *Judy Chicago*, Baltic Centre for
 Contemporary Art, UK.

2020
Chicago designs the 2020 Christian Dior Spring-
 Summer Haute Couture Show set.
Chicago in Ink: An Autobiography, an online exhibition
 presented by Salon 94, is launched. The exhibition
 is devoted to Chicago's extensive print archive and
 features numerous unseen prints.

Chicago collaborates with Dior for a second time, designing a custom Lady Dior handbag for the fifth edition of the Dior Lady Art project.

Call and Response, an exhibition of work by Chicago and Stanley Whitney, is presented in Shanghai by the Longlati Foundation, supported by Lisson Gallery and Salon 94.

Rainbow AR, an interactive augmented reality application featuring Chicago's *Smoke Sculptures*, is launched.

2021

Solo exhibition: *Diamonds in the Sky*, Through the Flower Art Space, New Mexico.

Chicago publishes *The Flowering: The Autobiography of Judy Chicago*.

Solo exhibition: *Judy Chicago: A Retrospective*, de Young Museum, San Francisco.

2022

Chicago launches *Chicago Gazette*.

She receives a Lifetime Achievement Award from the National Museum of Women in the Arts.

The Toronto Biennial of Art commissions Chicago to create a site-specific work to mark the closing of the festival.

Chicago is inducted into the National Women's Hall of Fame.

2023

Solo exhibition: *Judy Chicago: Herstory*, New Museum, New York.

ACKNOWLEDGMENTS

Firstly, my thanks and admiration to Judy Chicago, whose powerful words constitute the pages of this book. It is an honor to be aligned with such an inspiring mind, artist, and individual whose efforts have truly changed the course of art history.

My profound thanks to the studio of Judy Chicago, which enabled the production of this publication. Special thanks to Megan Schultz and Ron Longe. Many thanks as well to Daniel Trujillo at ARSNY for facilitating the production process.

I would also like to thank Jeffrey Deitch and his team for his guidance on this and many other projects.

My sincere appreciation to the entire team at Princeton University Press, especially Michelle Komie, Christie Henry, Terri O'Prey, Cathy Slovensky, Colleen Suljic, Laurie Schlesinger, Cathy Felgar, Jodi Price, Kathryn Stevens, Annie Miller. We remain extremely grateful to PUP for their continued professionalism, encouragement, and passion for our projects together throughout the years.

I would also like to acknowledge Lenny McGurr, Daniel Arsham, Brian Donnelly, Andy Cohen, John Pelosi, Angelo DiStefano, Karl Cyprien, Mike Dean, Louise Donegan, Sickamore, Ferg, Nigo, Sky Gellatly, Keith Miller, Sarah Sperling, and Rickey Kim.

Very special thanks to editorial director Fiona Graham for her invaluable research and organization of this publication.

My thanks as well to Susan Delson, and Xinni Ding for their editorial assistance.

My sincere thanks to Taliesin Thomas for her amazing assistance on this project and many others, and to Steven Rodríguez for his continued support.

Finally, I give all my bottomless gratitude to my amazing wife, Abbey, and to my wonderful children, Justin, Ethan, Ellie, and Jonah for their love and encouragement.

As always, I give endless love and thanks to my mother Judith.

LARRY WARSH

Judy Chicago is an artist and author of fifteen books. Her career spans almost six decades, during which time she has produced a prodigious body of art that has been exhibited all over the world. In the 1970s, she pioneered feminist art and feminist art education in a series of programs in southern California. She is best known for her monumental work, *The Dinner Party*, a symbolic history of women in Western Civilization executed between 1974–79, which is now permanently housed as the centerpiece of the Elizabeth A. Sackler Center for Feminist Art at the Brooklyn Museum. Subsequent bodies of work have addressed issues of birth and creation in the *Birth Project*; the construct of masculinity in *PowerPlay*; the horrors of genocide in the *Holocaust Project*, which she collaborated on with her husband, photographer Donald Woodman; and most recently, mortality and humankind's relationship to and destruction of the Earth in *The End: A Meditation on Death and Extinction*. Her work is in numerous collections and her ongoing influence continues to be acknowledged worldwide. Over the course of her career Chicago has remained steadfast in her commitment to the power of art as a vehicle for intellectual transforma-

tion and social change and to women's right to engage in the highest level of art production. Her first retrospective opened in 2021 at the de Young Museum in San Francisco and a second major retrospective will open at the New Museum in New York in the fall of 2023.

Larry Warsh has been active in the art world for more than thirty years as a publisher and artist-collaborator. An early collector of Keith Haring and Jean-Michel Basquiat, Warsh was a lead organizer for the exhibition *Basquiat: The Unknown Notebooks*, which debuted at the Brooklyn Museum, New York, in 2015, and later traveled to several American museums. He has loaned artworks by Haring and Basquiat from his collection to numerous exhibitions worldwide, and he served as a curatorial consultant on *Keith Haring | Jean-Michel Basquiat: Crossing Lines* for the NGV. The founder of *Museums Magazine*, Warsh has been involved in many publishing projects and is the editor of several other titles published by Princeton University Press, including Jean-Michel Basquiat's *The Notebooks* (2017), *Keith Haring: 31 Subway Drawings* (2021), and two books by Ai Weiwei, *Humanity* (2018) and *Weiwei-isms* (2012). Warsh has served on the board of the Getty Museum Photographs Council and was a founding member of the Basquiat Authentication Committee until its dissolution in 2012.

AUTHOR'S NOTE

First, I want to thank the publishers for pulling together so many "isms" that I didn't even remember and, of course, our incredible studio manager, Megan Schultz, for her hard work on the book. Secondly, I should probably explain that "Judy-isms" probably started long before I was Judy Chicago. When I was little, I was very close to my father, who is probably the source of all this. Freudian assumptions aside, he used to tell this story about when I was three, I took a bath with him and pointed to his penis, saying: "When I grow up, I'm going to have one of those," to which he responded: "Yes, if you're a good girl, you'll have one and if you're a bad girl, you'll have many." So—in all likelihood—my "isms" simply continued a tradition that he began.

ILLUSTRATIONS

Frontispiece: © Donald Woodman/Artists Rights Society, New York

Page 116: *Through the Flower*, 1973. Sprayed acrylic on canvas. 60 × 60 in. Collection of Elizabeth A. Sackler © Judy Chicago/Artists Rights Society, New York. Photo © Donald Woodman/Artists Rights Society, New York

ISMs

Larry Warsh, Series Editor

The ISMs series distills the voices of an exciting range of visual artists and designers into captivating, beautifully made books of quotations for a new generation of readers. In turn passionate, inspiring, humorous, witty, and challenging, these collections offer powerful statements on topics ranging from contemporary culture, politics, and race, to creativity, humanity, and the role of art in the world. Books in this series are edited by Larry Warsh and published by Princeton University Press in association with No More Rulers.